ROMANTICISM AND REALISM

by Norman Schlenoff
The City University of New York

McGRAW-HILL BOOK COMPANY

New York Toronto London

ROMANTICISM AND REALISM

Romanticism, with its roots deep in the past, shaped the cultural history of the nineteenth century and still tempers the creative impulse of artists today.

With the revolutions of 1776 and 1789 a feudal world was destroyed; and a new era began. Coal, iron and steam helped mechanize textile and other industries, and factories gathered the rural workers into urban conglomerations. With the growing industrial age the ordinary man demanded his share in the evolving democracies. The artist, no longer a dependent ward of an aristocratic patron, discovered his own strength and independence and began to paint uncommissioned easel pictures. Painting, once an aristocratic monopoly, became public property: anyone who felt he could paint was invited to take up a brush and to exhibit his pictures in the hitherto exclusive exhibition halls. Artist's materials became cheaper and readily available as a new chemistry and rapid mechanical looms furnished paints and paper and canvas in abundance. Expanding museums and avid bourgeois collectors eager for their portraits encouraged the liberated artists. The new themes needed no longer be stated cautiously; for instead of the discreet and refined vocabulary of the past, artists could now be bold and assertive — and even shocking, as were the group of Primitives in David's studio in 1800. Eccentricity and originality, along with the emo-

tions and instincts supressed during the previous century, flared up in the new nineteenth century; the artist strongly proclaimed new credos of liberty, equality, fraternity. The Romantic ferment, this dissolution of an old order and the genesis of a new order, excited the popular imagination; it strengthened the hope of a people encouraged by the transition of a dismal past to a promising future.

The Romantic had conflicting allegiances: to earth and sky, to consciousness and unconsciousness, to dark and light. He investigated the phenomena of the real world and its daily existence as painstakingly as do his heirs the Realists. But he also searched for the magical and irrational, the ethereal and dream-driven, or was intoxicated with youthful visions and became restless with unsatisfied yearning and daring aspirations. The Romantic championed the victimized and the downtrodden, and at the same time conjured up an invincible hero. Drawing on his emotional responses and spiritual exaltation, the Romantic expressed his immediate sensations, his specific reactions to experience. His sensibilities were impressed with an ever-changing nature, its variegated forms and colors, textures, lights, rhythms, movements; there he found new and strange meanings that were part of himself as they were part of the universe.

As he described and analyzed natural phenomena, the Romantic revealed himself a master of direct observation. However, he was tempted to identify his own emotional and spiritual reactions with the scene before him, so that the artist's temperament appeared as the real subject of the work. His heir the Realist decided not to allow such reactions to obtrude on an impartial and unbiased reportage of the natural world. Suppressing any Romantic identification with the subject at hand, the Realist hoped to demonstrate a scientific objectivity as he attempted to remove himself and his personality from the work of art.

A number of extraordinary Romantics emerged in the nineteenth century: Goya passionately revealing human darkness in conflict with human light; Blake intensifying the visionary and prophetic power of his art; Géricault and Delacroix deepening the drama of contrasts; Bonington and Constable opening the earth to the sky, commingling them in a sweeping pantheism; Turner and Friedrich weaving their webs of infinity and eternity. Chroniclers of light, air, atmosphere and the temporality enveloping all natural phenomena, Daubigny, Corot, Millet, Rousseau and Boudin explored the outdoor world. Romantics also strained their vision for clues dispersed in distance, darkness and dreams. But Daumier preferred the immediate and the present; he championed the world of ordinary men harassed by their bitter and daily lives — a theme his Barbizon friends espoused, though they felt an emotion and sentiment that ennobled man in the scheme of nature. Courbet, attracted to their world, promulgated a theory of Realism, where natural elements soberly assert themselves without regard for the painter's feelings about them; he painted what his Realistic eyes saw rather than what his Romantic heart felt.

Nineteenth-century Romantic art grew out of the eighteenth century art where charming and insouciant or erotic paintings were contrived in ribbons and skeins of soft and persuasive colors. Watteau's theme was continued by Boucher and Fragonard in an aristocratic rococo style — as in Fragonard's *Lover Crowned* (Figure 1), where happy fragile figures are dwarfed among splashing green trees. Other painters portrayed in a discreet realism, as did Greuze or Chardin, the unassuming occupants of quiet homes and the silent drama of pots and pans. In the meantime, a Neoclassical art, growing alongside the other styles, lauded ancient virtues and championed classical simplicity in noble themes on ancients dressed in the presumed robes of their time. Neoclassical art — challenging the frivolity, aimlessness and sheer *douceur de vivre*, or charm of living, of the rococo

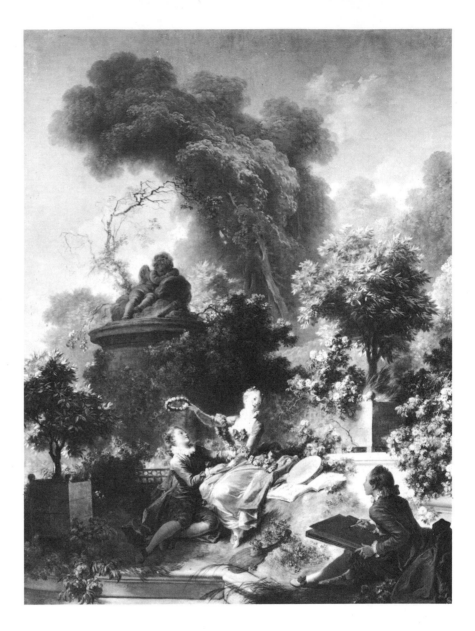

Figure 1. Fragonard: The Lover Crowned. Copyright The Frick Collection, New York

art — was serious, didactic, philosophic, moralistic and, in time, revolutionary: in a word, it was everything the rococo was not, and it soon won converts among the bourgeoisie. After 1789, with Jacques Louis David as its leader, Neoclassicism ruthlessly cast aside the rococo — along with Boucher and Fragonard and even King Louis XVI himself.

Neoclassical art, allying itself to the classical art of the past, asserted itself during the Napoleonic generation. This art formularized, learning from antique sculpture the acceptable norm for the human figure, equating the real world with an ideal one in which feelings and emotions were replaced by lofty attitudes and gestures. The restrained and cautious artist worked within the strict and formal balances of an art artificially constructed from the past rather than from direct experience: the moment represented was forever, without regard for the corrosive hour or man's mortality or environment's decay — as in David's *Death of Socrates* (Figure 2). Neoclassical art soon congealed in a frozen harmony and dry balance that strangled imagination.

Figure 2. David:
The Death of Socrates.
The Metropolitan Museum of Art,
Wolfe Fund, 1931

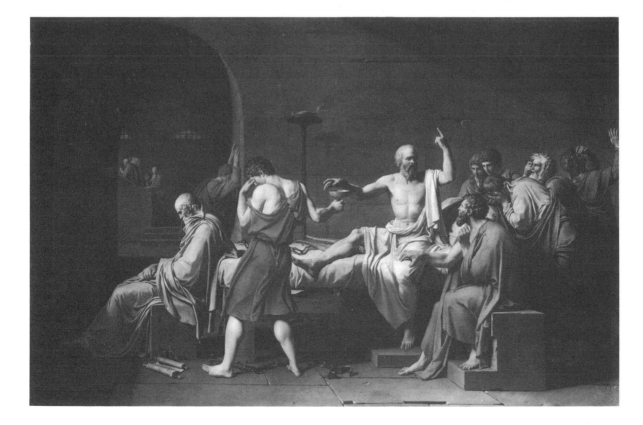

The Romantics, many of whom began as Davidian Neo-classicists struggling against their stultifying art, strove to restore humanity in this immobile equation of man, to infuse passion and emotion into what was cold and lifeless, and to present figures shaped by the forces molding the world about them.

At the beginning of the nineteenth century Romantic painters and writers, surveying a world torn between an opulent past and an uncertain future, explored the dark shadows of the bright rococo and rigid Neoclassical gardens. Planted there by English "graveyard poets" and gloomy German prophets, death suddenly appeared — a somber note in a frivolous destiny. Nature, powerful and menacing or omnipotent and sublime, impressed poets and painters. Blake added a visionary fire, infusing the extraordinary with the ordinary, as did the poets Wordsworth and Coleridge. Goethe's Werther became the victim of unquiet passion and spiritual agitation; and German writers introduced a new kind of hero who, as Madame de Staël popularized him in France, "showed all the forms of infinite nuances of what occurs in the soul." Rousseau had prepared the way with a return to natural emotions, and Chateaubriand described simple and primitive heroes. Social traditions were challenged by revolutions when the dissatisfied Romantic became aware of himself as an individual capable of shaping his own life on a heroic scale; for him passion vied with reason, or imagination and feeling with thinking. The present became unbearable as the Romantic yearned to escape, with the help of the arts, to a sympathetic future or a congenial past. By the beginning of the nineteenth century, medieval Christian ideals had been fused with those of the antique and Renaissance, to create a new hero — a complex, profoundly divided individual, a despairing and restless spirit soon to reveal a Byronic alienation.

In the first quarter of the nineteenth century Romantic artists and writers, emulating and inspiring each other, did not call their work Romantic. As innovators and experimenters, they

8

knew they were different; resuscitators and revivalists on one hand and revolutionists and anticipators on the other, the Romantics were also committed to interpreting their own time to their contemporaries. Some leaned on classic tradition but, like Byron or Goethe, poured new intoxicating wine into old formal bottles; or like Delacroix, adapted the techniques of Rubens, Michelangelo or Rembrandt to modern ideas. Many eighteenth-century techniques survived in the nineteenth, especially those flexible enough to convey a new message clearly and forcefully. In 1819 the Toulouse Academy suggested that Romanticism, as the new vogue was being called, could reinforce Classicism. But that was impossible. In the 1820's the avant-garde was about to challenge the conservatives to a battle. Coincident with Stendhal's prophecies on the new movement, *Le Figaro* of Paris announced in 1825: "Painting, like poetry, is divided into two parts: Romantic and Classic." Thereafter the two factions raised their own standards, and Delacroix and Victor Hugo bandied the new terms back and forth. The latter, in his famous 1827 preface to his play *Cromwell*, defined the terms of the struggle: the contrast of the sublime and grotesque, the beautiful and ugly, the dark and light — the contrast, in general, of opposites. Also in 1827 Ingres attempted to integrate the contending groups (whose banners were fanatically unfurled that decisive year) under a common paternity: the great Homer, from whom all creators in all fields descend to astonish their epoch. But the battle was on: the temperament and imagination and sensibilities of a Romantic coloristic Delacroix — versus the rational restraint of a linear Ingres reinforcing his pure abstract forms shaped and reshaped to express a self-contained and classic perfectibility.

The Romantic hero, self-made and self-directed, asserted himself in 1800 with David's *Bonaparte Crossing the Alps* (Figure 3), a painting of the great general "calm on a fiery horse." Despite the ordeal and danger, the hero appears un-

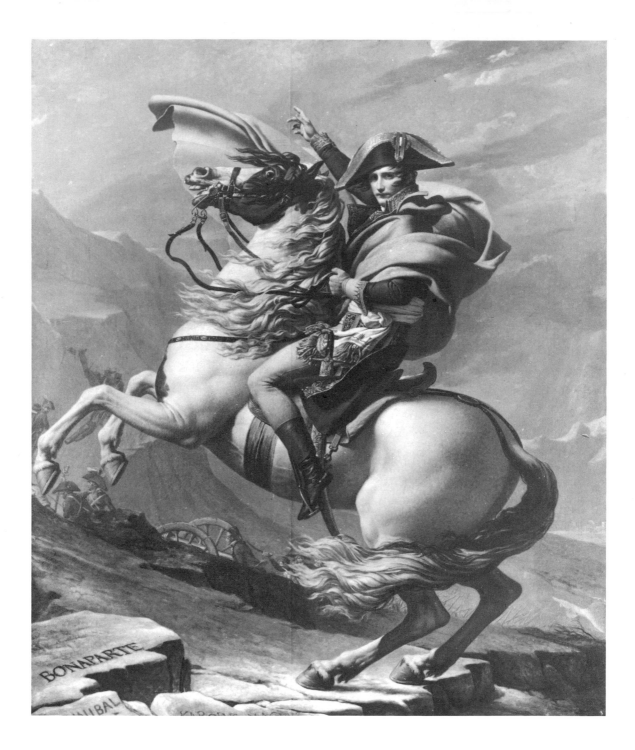

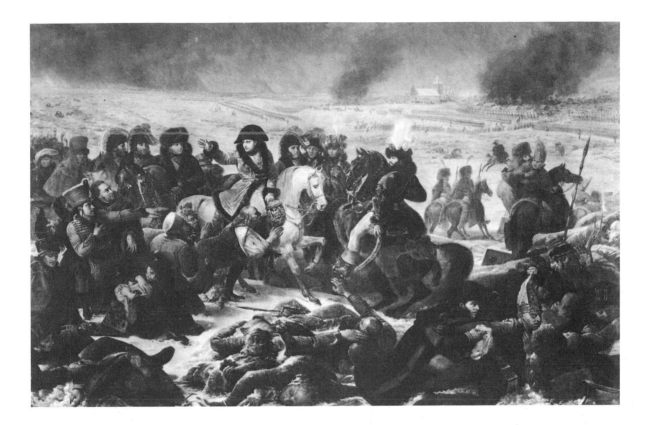

Figure 4. Gros: Battle of Eylau. Louvre, Paris

Figure 4. Gros: Battle of Eylau. Louvre, Paris

Figure 3. David: Napoleon Crossing the Alps. Malmaison, France

moved, indifferent to the tribulations and suffering of ordinary men; in the snow are the names of his great predecessors Hannibal and Charlemagne. Napoleonic painters emphasized this undaunted countenance surveying with equanimity disorder, bloodshed, death and violence. In this Romantic concept the hero becomes the protagonist of a challenging universe and remains indifferent to its perpetual threats; he successfully masters his environment by his attitude. A generation of painters carried this Byronic scheme forward. In the *Pesthouse of Jaffa* (Color slide 1) Antoine (later Baron) Gros represents Napoleon, surrounded by disease and death, calmly touching plague-stricken men to show that he is beyond contagion. Later, in Gros' *Battle of Eylau* (Figure 4), the Emperor, encircled by his generals and the wounded Lithuanians and Russians (representing the distant peoples of Europe who hail him as a new

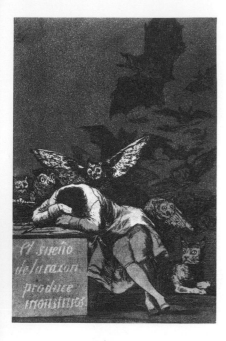

Figure 5. Goya:
The Dream of Reason Engenders
Monsters. (Etching and aquatint)

Alexander or Caesar), raises his eyes to heaven to disassociate himself from the mundane world of human suffering and death. In his apotheosis he manifests an exalted and even divine presence.

Napoleon dominates David's *Coronation* (Color slide 2), crowning the kneeling Josephine while others assist in a ceremony consecrating his act. Though the personages in this event are numerous, the fulcrum of the episode is Napoleon. Other artists celebrated Napoleon's military exploits, as did Girodet in his *Cairo Revolt* and themes on Ossian painted for the Bonaparte chateâu of Malmaison. Girodet often worked in an original (his teacher David called it "crystal") style, infusing his figures with an eerie luminosity — as in the *Burial of Atala* (Color slide 3); he also painted *Atala's* author, Chateaubriand in a tempestuously Romantic way.

Other artists, however, were eclectic and show different tendencies. Attracted to classical themes, Prud'hon preferred to create a sensuous human form, drawing it with a gentle caressing line. Subtle nuances of shading are found within his shadows, while a soft chiaroscuro contrasts black and white. In his drawings he is able to maintain a clear balance between oppositions of dark and light, but often in his paintings the bituminous pigment used in the shadows has absorbed much of the detail, as in his famous Louvre painting *Vengeance Pursuing Crime.* Prud'hon was regarded highly in his time. Delacroix praised his intimate *Portrait of Empress Josephine* (Color slide 4) with its "perfect resemblance" joined to the "sentiment of an exquisite loftiness of pose, expression and accessories," and noted further that "the melancholy expression anticipates her misfortune." This foreboding (of her divorce and royal eclipse) could hardly apply in 1805, her first triumphant year as reigning queen when the painting was completed, though it does demonstrate how a Romantic could read his own sensibilities into a work of art.

The Napoleonic imperial web gradually enmeshed Italy and the rest of Europe. Spain remained a pocket of resistance; there Francisco Goya, a witness to the military effort to bind Spain to the French empire, depicted the casualties of the war and the valiant struggle for liberation. Goya passionately described scenes of horror in paintings such as the *3 May 1808 in Madrid* (Color slide 5) depicting soldiers shooting civilians, and in his etchings the *Disasters of the War*. Goya's testimony is exact: "I saw it," he wrote on one etching. In the gloomy and dramatically persuasive scenes Goya, a participating artist involved in the political and social events of the time, emerges as an intense humanitarian. He used his art as a protest that is at once a particular and universal one. He makes ordinary men forceful and uncompromising martyrs, while in his aristocratic portraits his sitters often appear insipid and even stupid, as in his *Family of Carlos IV* (Color slide 6).

The Romantic artist reassessed another aspect of man, exploring the darkness for evidence of human behavior. In the *Dream of Reason Engenders Monsters* (Figure 5) and others from the *Caprices* and *Proverbs*, Goya etched a series of nightmares and visions, where dreams and imagination convey allegorical equations of human dilemmas and tragedies. Monsters of every sort, anthropomorphic and animal — man's perverse spirit — contrast with the light of humanity and truth. Barbarities appear in profusion in Goya's work as civilized appraisals of cruel and inhuman acts. Attention is turned to the calamities in daily experience: disease, death, plague, murder. The plague and war occupied many painters who observed on the battlefields the dead and wounded, the blinded heroes returning home (one of Géricault's themes), and carrion corpses and gorging vultures, the frighteningly diseased and mutilated — a spectacular dance of contemporary death. Together with these physical casualties, monstrosities and aberrations of the mind appear — the insane, the possessed, the visionary, the inspired,

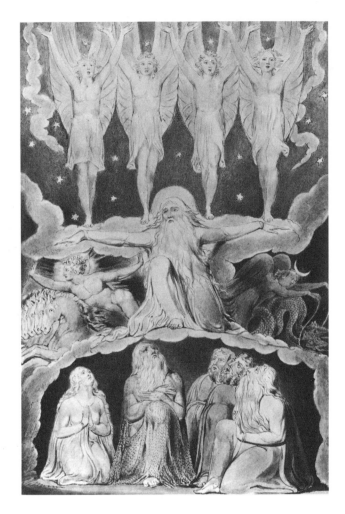

Figure 6. Blake: When the Morning Stars Sang Together. The Pierpont Morgan Library, New York

the dream-driven painter and poet, the drunk and the drugged — as in Fuseli's and Blake's work.

In England artist-poet William Blake, disenchanted with the 1789 French Revolution and its aftermath, withdrew from the world of events to the world of imagination. Formed by the eighteenth century, he often demonstrated a fusion of Classicism and Romanticism in presenting his extraordinary ideas in traditional and, later, unconventional forms. Inspired by the Bible and works of Swedenborg, Dante, Shakespeare, Milton,

Young and his own writings, he invented majestic theological figures capable of conveying the force of his spiralling linear message, as in the watercolor (Figure 6) and etching of *When the Morning Stars Sang Together,* or in the *Great Red Dragon and the Woman Clothed with the Sun* (Color slide 7). Blake contrasts purity with evil, and light with darkness in a Romantic allegory of the contending forces in man's heart and mind. The essence of Blake's message was to reveal itself intuitively through simple linear means, fortified, in his graphic works, with a color scheme evolved from his own technical inventions. Blake dreamed of freedom and brotherhood, and of an eternity where the individual could identify himself with the universe — the preoccupation also of German Romantics. He explored the naïveté of the child appraising the wonders and terrors of the world, the mystic reducing the many and great to the one and minute, or the world to a grain of sand or a flower.

Elsewhere in England topographical artists such as Thomas Girtin (who died in 1802) recorded the diurnal stress of time and season in his own country and in France. His watercolors, documents of human moods, are sensitively washed in broad areas of color. Richard Parkes Bonington studied with Francia, a close friend of Girtin whose works he sometimes copied, and developed the British penchant for stirring landscapes and cloud-capped hills. Settling in France, Bonington soon added a Gallic dimension to the sweep and movement of his landscapes, as in his *Parterre d'eau at Versailles* (Color slide 8). A sublime pantheism moves through the work of Romantic painters and poets. In their preoccupation with nature, the artists discovered sober Dutch landscape painting with its dramatic interplay of light and darkness over sturdy forms. Nature's advance through the seasons supplied a never-ending pageant of meaningful events. Against this background diminutive human activity paraphrased the arduous struggle of life and death.

John Constable observed the intricacy of man's environ-

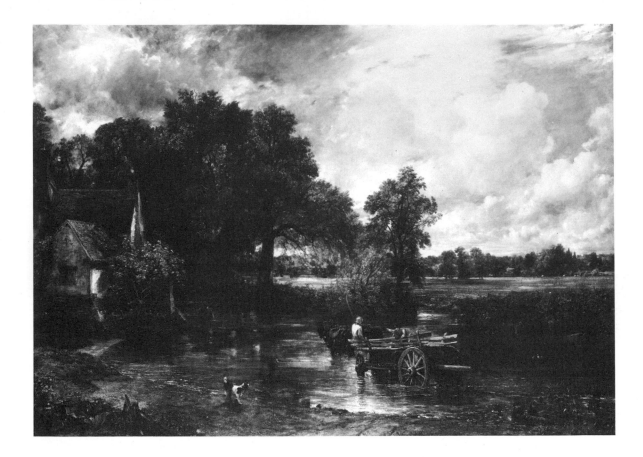

Figure 7. Constable:
Hay Wain.
The National Gallery, London

ment on farm and field; valley, hill and road, enveloped in natural light reflecting the shifting seasons, changed radically each hour, day or month. He dispassionately set down the nascent or dying light of mercurial weather and the mute events of his surroundings: the many changes in water, earth and sky, as in his *Wivenhoe Park, Essex* (Color slide 9). His descriptions, bursting from their terrestrial confines into the sublime and majestic contours of cloud-surrounded trees and hills, mysteriously transcend mere facts. His *Hay Wain* (Figure 7), showing the spontaneity and breadth of his vision and the freedom of his brushwork, inspired numerous French and British painters in its Paris exhibition in 1824. Impressed by the *Hay Wain*, Delacroix decided to repaint the surface of his *Massacre at Chios*

(Color slide 13), using a more scintillating paint to animate its surface.

The young Turner, attracted to this evocative translation of natural phenomena, turned to similar subjects. In time, however, he found the limitations of the diurnal and seasonal too constricting, and he expanded into the eternal and cosmic. Dramatic light, diffusing objects into a poetic configuration, disintegrates forms and promulgates the sheer force of light, smoke, air, fog in their cosmic and timeless passage. Great abstract splashes of paint send vivid colors in swirls and eddies athwart a dramatic predication as in *Rain, Steam and Speed* and the *Burning of the Houses of Parliament* (Color slide 10) — or in the *Slave Ship* (Figure 8), influenced by a passage in poet Thomson's *Seasons* and Turner's reading of an account of an epidemic at sea.

Turner's disintegration of terrestrial and atmospheric elements reduces human participation to insignificance, with the universe sweeping in an unfeeling wave over man's helplessness. Caspar David Friedrich wanted to remain a tangible part of the awesome unending spirit moving through all things: "I have to give myself to my surroundings, to be united to my clouds and rocks in order to be what I am," he said in true Romantic fashion, identifying the universe with his own feelings. Not indifferent Turneresque light but a supernatural light directly related to man's presence illuminates Friedrich's canvases and adds mystery. The anthropomorphic universe imitates the tragic gestures of mankind: light, trees, land, ice, all reflect the struggles of humanity — saved somehow by a divine intervention. The *Wreck of the 'Hope'* (Color slide 11), its symbolism strengthened by the double-entendre of the words in the painting, embraces several simultaneous experiences: visual, literal, personal, allegorical and even theological.

Such contending forces of man and the elements have still another proponent in George Stubbs (1724-1806), who exe-

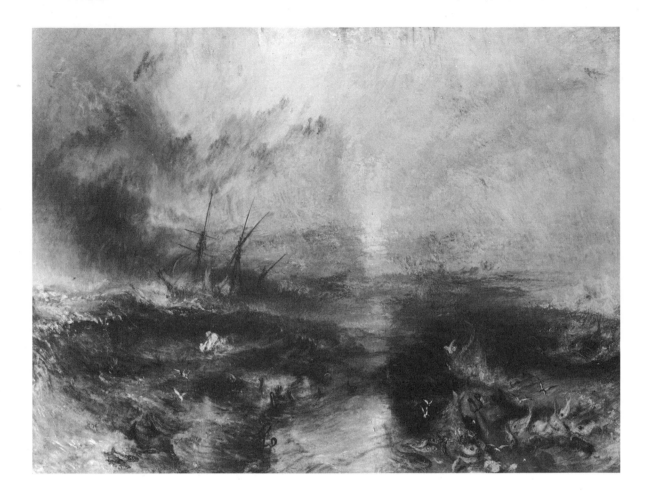

cuted numerous anatomical studies of horses and observed
scientifically the antics of monkeys and the behavior of wild
beasts. He pits a frenzied white horse against the elemental ter-
rors of thunder and lightning or the sudden challenge of a
powerful and deadly jungle beast, as in *Lion Attacking Horse*
(Figure 9), confronting the tame and benevolent with the fero-
cious and malevolent. His animal themes were admired by the
French Romantic artists Géricault, Delacroix and Barye.

Théodore Géricault, who studied the British achievement
and even copied the work of Stubbs, depicts the terrors of man
and beast in their threatening environment. Untamed horses

18

strain at their bit, bewildered and wounded soldiers stagger from the battlefield; and terror-striken men face the loneliness of the dark sea, as in the *Raft of the 'Medusa'* (Color slide 12). Attracted to the Goyaesque theme of the mutilated and suffering, Géricault carried his artistic investigation one step further: guided by clinical observation and advised by doctors, he studied physiology and pathology in hospitals and morgues. He also observed the cruelty of the slave trade and the execution by hanging in public places. To his vocabulary he added horror, depth of suffering, and man's depravity. In the lithograph the

Figure 9. George Stubbs: Lion Attacking A Horse. Yale University Art Gallery

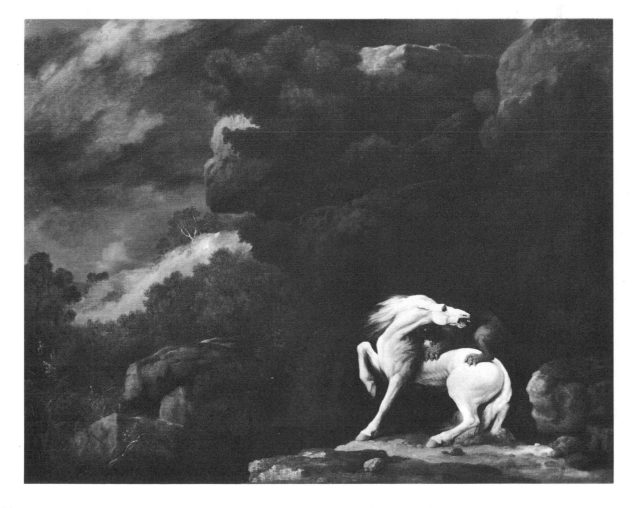

Paralytic Woman (Figure 10), for example, he portrays the plight of the infirm, contrasting the brutal indifference of the woman's attendant with the sympathetic distress of the child guiding a baby as dependent as the sick woman. In another lithograph an old man, blind and helpless and removed from any human compassion, sprawls in the streets. With Géricault a new realism begins to emerge with Romanticism: it exaggerates the horrible and accentuates the macabre and grim, protesting at the same time it portrays the human condition. Yet in the final commitment to canvas, into the light and dark of drawings and prints that are never a mere enumeration of facts, his work moves us with its dramatic conviction and painterly truth — the force of his art.

Géricault's friend Eugéne Delacroix continued to explore the dramatic Romantic vocabulary. In 1822 his *Bark of Dante*, inspired by a study of Rubens and Michelangelo, shows tortured human souls set against a dark and cataclysmic background. His *Massacre at Chios* (Color slide 13) investigates the terror of vanquished civilized people; and his *Death of Sardanapalus* (Color slide 14), annihilation through fire and smoke. An 1830 theme on the barricades, describing an actual revolution in the city of Paris, helped steer the Romantics toward com-

Figure 10. Géricault: Paralytic Woman. (Lithograph)

mitted pictorial aims. In his Rubenist (after P. P. Rubens 1577–1640) canvases he agitated the mechanism of his compositions: restless forms move and merge into one another, flowing through space and out into the distance, as in the *Abduction of Rebecca* (Figure 11). In this scene of Knight Templar Brian de Boisguilbert abducting Rebecca from the castle of Torquilstone (inspired by the most popular Romantic novelist Sir Walter Scott), the painter treats each element as an equal component in the structure of the canvas. Horse and rider and victim all flow into one another and downward or upward along dizzying diagonals, in a colorful and impetuous motion, while flame and smoke dissolve the restless surface of the canvas. To engross the eye in an all-over experience, Delacroix did not hesitate to break the volumes of figures and objects by a *touche* that winds them fluidly into the color scheme of the composition, accentuating the visual flow and exploring new uses of paint to create a striking effect. Heightening the universality of his theme, he stressed musical and color harmonies and strengthened the philosophic and moral persuasiveness of his message. For Romantics in all countries enjoyed borrowing the devices and techniques of colleagues in other fields, so that poetry and painting echoed music and vice-versa.

To intensify the spectator's participation in the scene, Delacroix vividly contrasts opposites: physical dark with spiritual light, the weak and the cruel, the ugly with the fair — even as Victor Hugo counseled his fellow-writers. Drawing on the strange and exotic, Delacroix reworked the testimony of other times into an eclectic fabric, editing costumes and characters and décor into a living inspiration, and recreating the past with a new and original magic. Many of his contemporaries were attracted to this near and far past: Devéria with the *Birth of Henry IV*, Raffet and Charlet with ghosts of Napoleonic armies sweeping to victory, neo-gothic illustrators, Doré interpreting Dante and Shakespeare; and further in the century, Bresdin

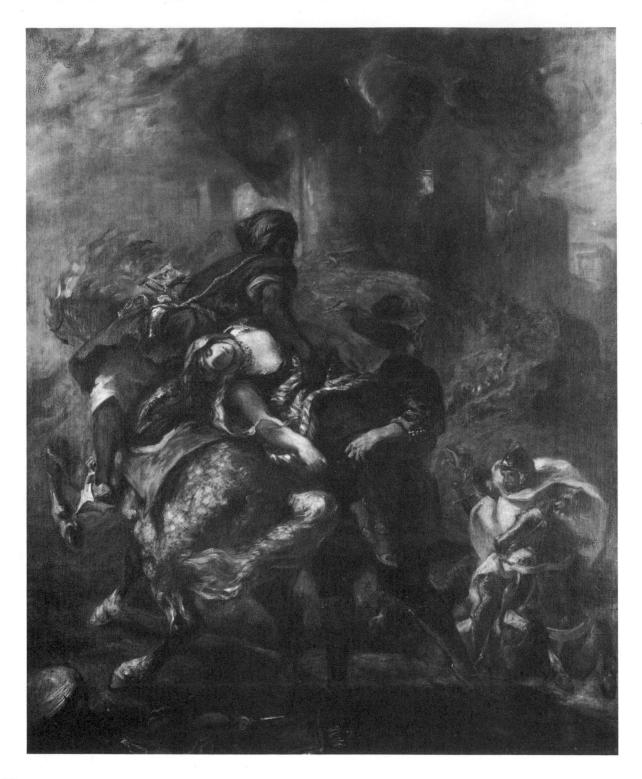

22

and Meryon plumbing the fearful commonplace of the strange city, Félicien Rops invoking the Devil, Hugo conjuring up the diabolical tenacity of darkness, and poets Nerval and Baudelaire extolling the dark beauty of man's satanic passions.

J.A.D. Ingres, Delacroix's rival, chose the classical world of Raphael (1483–1520) and Poussin (1594–1665). In his clearly-presented themes, figures are equated with each other as pictorial co-efficients; colors echo adjacent colors, contrasting with or completing them in a determined scheme. The human figure, an inviolate island secure within a strong linear outline, is purposely isolated against the background it dominates. Yet Ingres shows his penchant for the fantastic Scottish antiquity in a theme on Ossian, where the specters of a mysterious army gather

Figure 11. Delacroix: The Abduction of Rebecca. The Metropolitan Museum of Art, Wolfe Fund, 1903

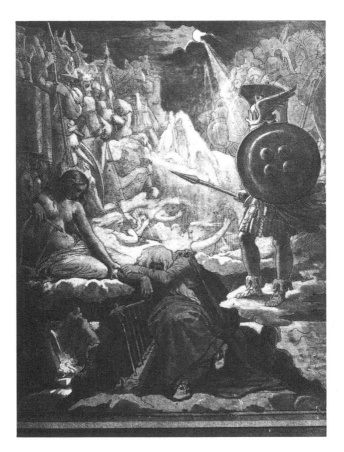

Figure 12. Ingres: Dream of Ossian. Louvre, Paris

in the moonlight. In the *Dream of Ossian* (Figure 12) the young woman Malvina comforts the blind bard Ossian, now asleep and dreaming. In the center of the scene the white-haired "Starno, the snow-king with black eyebrows," reclines among warriors who retain "their shield and lances in memory of their exploits and triumphs," (in Ingres' words) while dogs bark and wandering spirits play harps. In his *Odalisque with Slave* (Color slide 15) Ingres explores a Near-Eastern subject of harem and slaves, with the sultana sensually reclining in a bizarre and erotic setting.

This setting also appears in the harem scenes of Ingres' disciple Chassériau, in whose work an Ingres' linearism persists — especially in several oil portraits such as the *Two Sisters* (Color slide 16). Chassériau, attracted to the orientalism of the Romantics, synthesizes Ingres' monumental vision with Delacroix's emotional rendering of form. To his own painting he adds a suavity, something voluptuous and svelte. In the yearning upsurge of his themes, through which he nevertheless attempts to maintain clear forms, Chassériau inspired such late Romantic painters as Gustave Moreau.

At first allied to the Romantics, new landscapists appeared and in time emancipated themselves by their credo, purpose and moral. Charles Daubigny, one of the new group known as the School of 1830, drew his inspiration from the same sources as those attracting Constable and Turner. The complex personality of nature impelled Daubigny to investigate the beauty of rustic scenes about him: animals in search of fodder, river banks with moored barges, farmyards quiescent after a day's toil as in *Evening* (Color slide 17). In rendering this simple setting Daubigny pays to nature a homage that seems to pour spontaneously from him and reveals a personal attitude toward painting that transforms reality into another kind of experience. This attitude also characterizes the painting of his colleague Théodore Rousseau; they, with others espousing their

bucolic theme, soon became known for a particular vision known as the School of Barbizon. In *Leaving the Fontainebleau Forest* (Color slide 18) Rousseau's setting is similar to Daubigny's rustic one. Impressed with the solidity of Flemish and Dutch seventeenth-century landscapes, even as their British colleagues were, the Barbizon painters admired the solidity of trees and rocks, paths beaten by human beings and animals, and ordinary activity of people on farms and in fields. Daubigny and Rousseau elaborated on the generous light flooding through clouds and forests, indicating the plentitude of summer and autumn and the attendant weather at the recorded hour; they are the direct precursors of the Impressionists whom they knew and admired and who admired them in return.

Jean-François Millet, a close friend of Théodore Rousseau, lived with his wife and children — who often appear as subjects

for his numerous drawings and oil paintings — in the village of Barbizon on the edge of the Fontainebleau forest. Millet's favorite theme is man laboring diligently and arduously through the seasons. *Bringing Home the Newborn Calf* (Figure 13) represents man enveloped in the large pattern of regenerating nature, ceaseless in its demands, blending man, animal and vegetation into a sympathetic coexistence. "My program is work. That is the natural condition of humanity," he explained, paraphrasing the Bible that inspired him. " 'In the sweat of thy brow thou shalt eat bread' was written centuries ago. The destiny of man is immütable and can never change." Thus such scenes as the *Gleaners* (Color slide 19) offer an eternal message that seems to be audible in his next picture the *Angelus*. Not intent on a faithful reportage of the hard life about him, he often weaves the noble peasants into his background, rounding their forms with a soft shadow as they move through their monotonous tasks. Often the figures are absorbed into a simplified silhouette as are the women in the *Gleaners*. Millet is not content with the human figure as he finds it; he makes it more malleable for the domestic subject on hand. "Beauty does not consist in the shape or the coloring of the face. It lies in the general effect of form, in suitable and appropriate action."

Camille Corot can be counted in the company of the Barbizon painters, though his art differed from theirs. Before innumerable topographical vistas, he composed on canvas the delectable site, emphasizing "always the mass, the whole, that which one has found most striking," as he explained. "Never lose the first impression which has moved you." Corot's reaction to his visual experience is rendered simply, even cubically, in cautiously related colors contrasting with a small dash of red. A marvelous restraint characterizes his themes on Italian cities and, later on, those in France, as in his *Cathedral of Chartres* (Color slide 20), a scene described in subtly contrasting colors. As he grew older, Corot diffused his color schemes in misty at-

mosphere and feathery trees, all wound into a grey or silvery grey-green tonality sweeping serenely across his canvases. His sitters became nostalgic and withdrawn and showed in their absorbed reverie a deep melancholy. In his *Souvenir of Morte-fontaine* (Figure 14) Corot peoples his sylvan setting with carefree figures moving in a mysterious and gentle light. In time he introduced nymphs and satyrs into his forest and lightened even further the enchanted scenes.

Corot's friend Honoré Daumier chose humble city people for his program, often sketching them in dramatic contrasts of bright light and startling dark. Daumier championed social issues and investigated the pressing problems of ordinary people,

Figure 14. Corot: Souvenir of Mortefontaine. Louvre, Paris

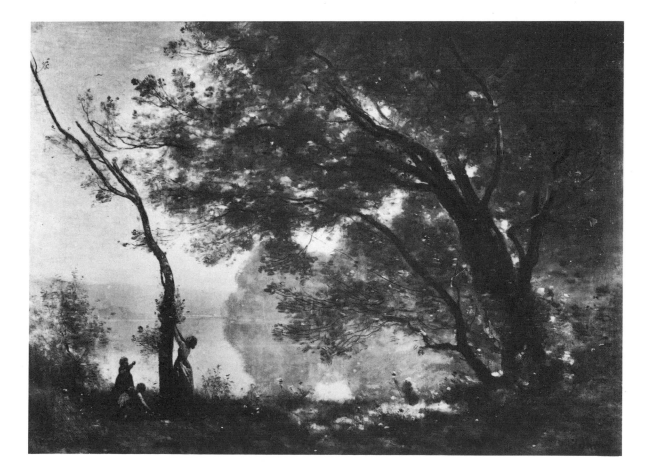

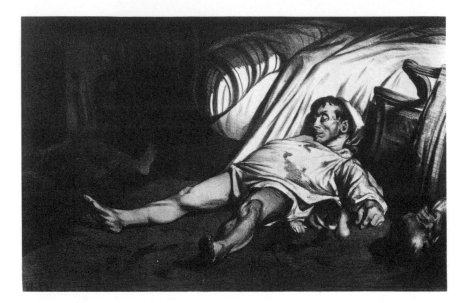

Figure 15. Daumier:
Rue Transnonain.
(Lithograph)

commenting on their bitter lot and emphasizing their patient endurance. In acid tirades against injustice, inhumanity and social indifference, he presented nervously melodramatic and agitated figures engrossed in their daily lives. In a series of lithographs for newspapers and magazines his work enjoyed a wide popularity, but it earned him the enmity of the government that he criticized so harshly. He denounces in *Rue Transnonain, April 13, 1834* (Figure 15) (a lithograph exhibited conspicuously in a store window), the royal soldiers of King Louis-Philippe who massacred the occupants of an entire tenement house in retaliation for their republican taunts. The gruesome and bloody scene describing the fate of one family is moving in its pathos and shocking in its brutality. A powerful light cascades over the bed and along the inanimate form of the man, whose outspreading hand embraces the crushed child in a spidery composition of death. A master of contrasts, Daumier opposes the semi-shadow absorbing the woman's form with the accusing spotlight. For his pictorial journalistic activity Daumier spent time in jail; but released, he never tired of his role of

historiographer of people, wherever they might be — at home, on beaches, in the street, at parties, in law courts, in prison, or at the theater. In *Crispin and Scapin* (Color slide 21) Daumier paints a scene from a play. A Romantic in his emotional and passionate attachment to actuality, he avoided escapism into the past and remained the articulate and compassionate journalist — artist of contemporary humanity. Poor and neglected in his old age, Daumier was helped by "Papa" Corot — enormously successful with his silvery-grey and wistful painting.

From 1830 to 1850 Delacroix and Ingres further developed their styles and had their followers and imitators, while others were busily Romanticizing and Classicizing. Several painters identified themselves with the Barbizon masters. Still others flourished in a thriving art world, successful eclectic painters who leaned on the great traditions of the past. They studied the outstanding work of their own generation and of the older generation of David, Gros, Girodet, and Guérin (who had taught Géricault and Delacroix); many of whom had chronicled the Napoleonic era and the successive reigns of restored kings. Inspired by the achievement of the great military painters active in the first-half of the century, they searched for an epic theme. Horace Vernet (1789–1863) painted several historical scenes of battle and conquest, as did his son-in-law Paul Delaroche and numerous painters who might be called a branch of the Romantics — the *juste-milieu* (the Golden Mean or Happy Medium) painters who used Delacroix's color and Ingres' line and form. Remembering the Napoleonic insistence on the significant and timely theme, they narrated episodes from French and English history, the tragedies of great kings and queens, and the careers of Renaissance geniuses whose styles they also imitated. They were correct and cautious realists who painstakingly interpreted the visual world: tables and chairs, windows, floors and ceilings were shown precisely as they appeared to the eye, while real air and light flowed around rigid figures and objects.

Paul Delaroche (1797–1856) in the *Children of Edward IV* (Figure 16), painted in 1830 and exhibited the next year, demonstrates the *juste-milieu* formula. He scrupulously models the young bodies and unsparingly indicates every detail of the wooden bed. The painting recounts the murder in 1483 of the sons of Edward IV. The two young princes hear the door open, and a slight crack of light appears; the dog sniffs out the intruders — murderers are about to enter. The painter arrests our attention and pleads with a special pathos, adding to his art something startling and theatrical. This school of art, readily adaptable to portraiture and to scenes of social life when it did not masquerade, appealed especially to the bourgeoisie, who appreciated its transliteration of reality. The *juste-milieu* painters soon observed that their embarrassing rival the photographer threatened their existence. Nevertheless they persevered, claiming artists could choose what they saw, arrange, eliminate, and make sublime and lofty what was not already so; color too was their monopoly in this new competition with the camera. Their vogue was successful all over Europe and even in the United States, and they flourished down to the end of the century and beyond — during which time Impressionists and other new artists struggled against them.

The Romantic painters, ever active alongside their *juste-milieu* confreres, prepared the way for a fresher and more spontaneous appreciation of man and nature. Examining and analyzing the various facets of outdoor experience, Daubigny, Rousseau and Millet contemplated landscapes where matutinal and crepuscular light blended all visible things into a striking unity, shaping objects, emphasizing color, composing appealing scenes. The heritage of earlier painters was handed down too: that of dramatic landscapist Georges Michel or of theoretician Valenciennes, an astute observer of natural phenomena who influenced Corot and his generation. Eugène Boudin, along with the Dutchman Jongkind, offered a new vision of nature that

had something in common with his Barbizon predecessors and, at the same time, something different. In *Normandy Women Spreading Wash on the Beach* (Color slide 22) Boudin uses his brush with almost careless spontaneity, rendering an accidental scene that appears effortlessly composed. The grey light and the almost bare beach scintillate with brushstrokes, approximating the restless forms of individuals and the agitated movement of wind and clouds. Boudin prefers to turn his attention to "those middle class people strolling on the jetty at the sunset hour," for "they are often resting from strenuous work, these people who leave their offices and cubbyholes." Along with Jongkind, Boudin revealed to Monet how to capture the transient temperament of the casual site, allowing the haphazard accidents of the scene to speak for themselves. He even encouraged the famous Impressionist dealer Durand-Ruel

Figure 16. Delaroche: Children of Edward IV. Louvre, Paris

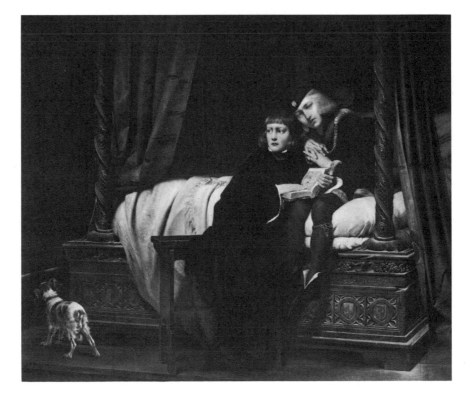

(then buying Barbizon along with Boudin works) to buy Monet's paintings. Working alongside Boudin and Courbet, Monet eagerly absorbed the message of the two masters.

By 1830–1850, then, the real world of objects claimed men's attention. Coming to fame during the 1848 Revolution, Gustave Courbet would have none of the *juste-milieu* artificiality, the Barbizon painters' deep human sentiment, Delacroix's Romanticism, or Ingres' classicism. Courbet, a Realist, proposed to paint exactly what he saw, neither manipulating the truth of his information nor supporting the methods of any school; for he felt "there can be no schools, there are only painters." Courbet exhibited his *Stone-Breakers* in 1849, a humble scene of industrious workers. Though Barbizon masters investigated similar subjects, they did not see as Courbet did. He idealized as little as possible; guided by the actual scene in plain daylight, he excluded any of the spiritual intrusions that transformed Barbizon reality. He stressed the casual coarseness of humanity and the accidental disposition of terrain with haphazard objects upon it. To approximate more closely the visual aspect of nature, unpremeditated and felt with immediacy, he used a palette knife to indicate earthy colorations and patched in effects with his thumb. In the *Funeral at Ornans* (Color slide 23) a solemn procession of his country neighbors halts alongside a newly-dug grave, with whose sad earth the villagers acknowledge a drab consanguinity. In such everyday scenes of people and places he knew, Courbet continued to expand his program. In his *Demoiselles de Village* (Figure 17) he represents, at La Roche de Dix Heures (rocky hills near his native village of Ornans), his three sisters (who also appear in the preceding painting): Zoë with a large hat, Juliette carrying a parasol, and Zélie turned toward a young shepherdess. Apparently unposed, the three promenaders are casually arranged across a narrow proscenium. Courbet contrasts his sisters' bourgeois costumes with the little girl's tattered clothes and records

the accidental landscape. Details are soberly noted, nothing added and nothing subtracted. Courbet continued to paint in this moderate way, soberly revealing the unprepossessing faces of his friends, though he sometimes was tempted to over-dramatize in caressing shadows his own portrait and those of others. He continually demonstrated an enviable technical excellence in his instinctive awareness of apposite details and color harmonies skillfully organized in a striking composition. In his affirmation of an individual vision and the painter's personality shaping it, Courbet extended the Romantic tradition. An individualist, he grew out of his environment — his recurring

theme — and had sympathy only for those people who shared his life or his experience. Courbet, his own Romantic hero with a triumphant manifesto, created his world from the visible and contemporary — the real world that had stirred the Romantics from the century's beginning and had shaped their art.

Near the Paris World's Fair of 1855 Courbet held a one-man exhibition with, among other paintings, *The Painter's Studio* (Color slide 24) — a study of the elements of his time-environment as they affected his own life. With this extraordinary scene Courbet brought his Realism back to the mainstream of Romanticism, from which movement it had once emerged. And the young painters(Manet, Degas, Renoir among them) who will form the phalanges of the new art movements, studied the achievement of Courbet (and of his predecessors and contemporaries on view at the same Fair) for some tangible indication of a direction they might themselves pursue.

· 1 ·

BARON ANTOINE GROS
(1771–1835)
Pesthouse of Jaffa
(1804)

Oil on canvas, 209½″ x 283½″
Louvre, Paris

During his Near-Eastern campaign General Bonaparte learned that rumors of the plague were demoralizing his army. To reassure his soldiers, he visited on March 11, 1799 the lazaret of Jaffa, a deconsecrated Greek church. Napoleon is shown here as he walks among the plague-striken men. Accompanying him are General Bessières (who timidly holds a handkerchief to his nose to indicate a terrible stench) and other members of his staff. Encouraged by the pioneer of vaccination Dr. Desgenettes (standing behind him), Napoleon touches one of the afflicted, emphasizing the direct contact of his bare hand by holding his glove in his other hand. The gesture symbolizes a divine healing touch, formerly possessed by royal kings to cure diseases, and as such it endows the hero with spectacular magical powers. At the far right the dedicated surgeon Masclet is dying. Around the room the moribund sprawl, and from one side a man striken with opthalmia approaches the visitors. To make his picture acceptable to the regime, Gros plunged into darkness the lurid foreground, where obscure and vociferating figures contrast with the uneven light focusing on the chief actor. The blues and whites of the uniforms set the color scheme in this bizarre interior, where he emphasizes the physiognomy and costumes of the natives. The tortured and despairing characters, the unusual depiction of disease and death, the suffering and agony reinforce the Romantic theme.

· 2 ·

JACQUES LOUIS DAVID
(1748–1825)
Coronation of Napoleon
(1808)

Oil on canvas, 240⅛″ x 366⅜″
Louvre, Paris

Shortly after being crowned Emperor of France on December 2, 1804, Napoleon ordered this huge painting from David. The artist, guided by numerous notes and sketches and assisted by disciples, painted it during 1806 and 1807. The scene takes place in the choir of Notre Dame Cathedral, decorated for the occasion with neoclassical props. The main participants of the coronation are presented in groups: in the center, Napoleon, blessed by Pope Pius VII, moves forward to crown the kneeling Josephine; directly to the left, Napoleon's now-royal sisters and brothers; in the tribune above, his mother Letizia (who was not present at the actual ceremony) and David with fellow-artists; to the right, churchmen and, beyond them, ambassadors; in the right foreground, imperial dignitaries such as Talleyrand.

The moment represented here is based on actual historical data, in a new sort of documentary realism that David adumbrated during the preceding decade. In a setting derived from the overarching space of Italian early-Baroque painting, the actors are clearly realized, shaped by real light falling upon them. Costume, jewelry, fabrics and decoration are painstakingly rendered but subordinated to a great painterly scheme. Atmosphere and mood and the absorbed participation of each character further help to unify this ambitious painting of a magnificent and impressive ritual.

35

· 3 ·

ANNE LOUIS GIRODET
(1767–1824)
The Burial of Atala
(1808)

Oil on canvas, 82⅝″ x 105⅝″
Louvre, Paris

Girodet derived his theme from Chateaubriand's *Atala, or the Love of Two Savages in the Desert*, a novel reaffirming the author's Catholic faith after a period of doubt and despair. In the story Chactas, a Natchez Indian, describes his life to René, a French refugee in Louisiana. Atala, vowed to the service of the Virgin Mary, commits suicide to triumph over her love for Chactas. Father Aubry, a French missionary, helps bury the young Indian woman in a grotto. On a wall to the right appear these lines: "Like a flower I withered, like the grass in the fields I dried." Lifeless Atala, clasping a crucifix in her hands, is about to be buried in a tomb. Light streams past a cross outside to flood the interior of the grotto, illuminating her form. At her head is the figure of Aubry, and at her feet the mourning body of Chactas. Girodet treats the body in broad contrasts of light and shade, emphasizing its contours to strengthen the fine diagonal curve uniting the three figures, and inventing luminous *sfumato* colors to add mystery and pathos. In the midst of artificial colors contrived by the painter, the white shroud contrasts startlingly with the dismal interior and drab garments of the old man and the coppery body of Chactas. In this scene of noble savages, influenced by Rousseau and later kindred writers, the atmosphere of piety and grief helps place this work among the Romantic documents of the period.

· 4 ·

PIERRE PAUL PRUD'HON
(1758–1823)
The Empress Josephine
(1805)

Oil on canvas, 96″ x 70⅜″
Louvre, Paris

Empress Josephine of France was born Josephine Tascher de la Pagerie in 1763 in Martinique; after the death of her husband Vicomte de Beauharnais, she married in 1796 the young General Bonaparte — six years her junior. He divorced her in 1810 for her failure to produce heirs. In 1814 she died in the château of Malmaison, the setting of this painting.

In this portrait the newly-crowned Empress is shown in her private garden, a remote and romantic spot, with a profusion of identifiable flowers at her feet, for she was an ardent botanist. Also an art collector, she befriended David, Gros — and Prud'hon from whom she ordered this portrait. Prud'hon presents his sitter in a simple décolleté robe embroidered with gold. Informally posed in a slight *contrapposto*, or turning of the body, Josephine exists in space as naturally and romantically as do her flowers. Prud'hon encircles her head with her arms, cutting into two the strong color rhythm of the red shawl. Italian influences abound in the painting: Titian colorism, Correggio *sfumato* and pose, and Leonardo da Vinci nuances. The human form, isolated against the brown and verdant earth, is infused with a poetic pensiveness to emphasize the sitter's solitude. The relaxation of the figure and the charm and grace of the features reflect the casual, intimate atmosphere of the eighteenth century that both Josephine and her painter vividly remember.

· 5 ·

FRANCISCO GOYA
(1746–1828)
3 May 1808 in Madrid
(Painted after 1814)

Oil on canvas, 104½″ x 135⅝″
Prado Museum, Madrid

Between April 20 and April 30, 1808 the two kings of Spain, Carlos IV and his son Ferdinand VII, abdicated their throne — which Napoleon promptly gave to his brother Joseph. On May 2 in Madrid the patriotic Spaniards rose in sudden revolt against the French, the signal for further uprisings everywhere in the country. In 1814, after the liberation of Spain, Goya received two commissions for paintings to commemorate the nation's struggle: *2 May 1808* tells the story of the reaction of the citizens to the occupation, and *3 May 1808* depicts the shooting of hostages on the Mountain of Prince Pio. The May 3 episode, similar to *There is No Remedy* in the series of engravings for *Disasters of War*, accents the luminous target of a victim in the form of a Saint-Andrew's cross. He is part of a group of five men and a priest (whose faces form a *Y*) rising out of a knot of executed hostages; a new group moves up to be massacred. The spotlighted everyman-martyr, heroically defiant with his bright truth, stands out boldly against the surrounding blue-and-green-ocher of mottled cloth and carmine blood. An uneven light emanating from a yellow and white lamp unites the body-targets, dramatically illuminating the victims. The solid bodies of the faceless soldiers are outlined in strong silhouettes. The machine-like orderliness of military actions contrasts with the helpless and formless huddle of the executed and the menaced. Here terror and anguish are pitted against merciless disciplined death: Goya's vivid protest against the inhumanity of war.

· 6 ·

FRANCISCO GOYA
(1746–1828)
Family of Carlos IV
(1800)

Oil on canvas, 110¼″ x 132¼″
Prado Museum, Madrid

Painted at the royal residence of Aránjuez in the spring of 1800, this scene presents the Spanish royal family with the women wearing the order of Queen Maria Luisa and the men the order of Carlos III. At the left Goya stands before his easel flanked by the future Ferdinand VII with his betrothed, and his younger brother Carlos and the King's sister Maria Josefa. In the center are Queen Maria Luisa with Infantes Maria Isabella and Francisco. King Carlos IV now appears with his brother Antonio and sister Carlota and his daughter Maria Luisa with her husband Prince Louis of Parma and their child. In the background two huge paintings cover a blank wall and enframe many of the faces.

Satins and silks and ribbons, in blue, vermilion, pink, green, red, brown, orange and white, all mutedly related in soft tones, unify the numerous personages, posing here in a traditional manner echoing Velásquez' *Las Meninas*. Natural and informal in an eighteenth-century manner, the figures are not idealized; they seem unconcerned about their ignominious reputation: the lascivious queen dominating the weak and foolish king posing with his treacherous and cruel heir. The work's spontaneity and glitter pleased the patrons, indifferent to their own commonplace and ignoble pretensions mirrored in it. The virtuoso facility of Goya's brush, conveying the elaborate courtly accoutrements, and the pastel tranquility of the faces so subtly woven into the broad composition are most admirable.

· 7 ·

WILLIAM BLAKE
(1757–1827)
*The Great Red Dragon and
the Woman Clothed with the Sun*
(Painted between 1805–10)

Watercolor, 15¾″ x 12¾″
National Gallery of Art
Washington, D.C.
Rosenwald Collection

Revelation, Chapter 12: "And there appeared a great wonder in heaven; a woman clothed with the sun, and the moon under her feet, and upon her head a crown of twelve stars: And she being with child cried, travailing in birth, and pained to be delivered. And there appeared another wonder in heaven; and behold a great red dragon, having seven heads and ten horns, and seven crowns upon his heads. And his tail drew the third part of the stars of heaven, and did cast them to the earth: and the dragon stood before the woman which was ready to be delivered, for to devour her child as soon as it was born." After the birth of the child, the dragon "persecuted the woman" who is "given two wings of a great eagle, that she might fly into the wilderness." The woman represents innocence and goodness, and the dragon (satanic in his rebellion against God) the evil forces that are "wroth with the woman" and "the remnant of her seed, which keep the commandments of God." Blake forcefully contrasts the luminosity of the woman with the tenebrosity of the dragon; with colors diametrically opposed and gestures keyed to each other in threat and defiance, they are rhythmically balanced. The purity and simplicity of the woman make more alarming the complex malevolence of the dragon. Blake emphasizes the ample linear contour of figures in pure color washes; the flowing movement of his figures are conceived in shadowless forms aligned to the picture surface.

· 8 ·

RICHARD PARKES
BONINGTON
(1801–1828)
The Parterre d'eau at Versailles
(1827)

Oil on canvas, 16½″ x 20½″
Louvre, Paris

Young Bonington, an Englishman, moved to Calais and there studied watercolor. In 1820 he entered the Paris Ecole des Beaux-Arts to continue his career under Antoine Gros, then championing Davidian classical painting and Napoleonic Romanticism. Influenced by the vision of his French colleagues such as Delacroix, Bonington soon added a Gallic dimension to his native vision and participated in the Paris exhibition of 1824. Delacroix admired his "great facility in rendering his subject," marveling at the "absence of effort and the great ease of execution" as well as the "dexterity" with which he quickly brushed in his subjects. In the *Parterre d'eau at Versailles,* a rapid oil sketch of that basin of water directly behind the palace's central *terrasse* (between the rear facade and the Latona steps leading to the fountains below and the great park), Bonington introduces the figures of children, nurses and soldiers to set off the general patterns of the water-parterre moving upward toward the outlined mass of the palace and the cluster of trees of the north garden. Sketchily painted in natural colors, the scene has a breadth and spontaneity, almost a watercolor directness. As the foreground rises vigorously to meet the onrushing sweep of tumultuous clouds, it embraces the casual strollers and pantheistically absorbs them into the Sunday afternoon.

· 9 ·

JOHN CONSTABLE
(1776–1837)
Wivenhoe Park, Essex
(1816)

Oil on canvas, 22⅛″ x 39⅞″
National Gallery of Art
Washington, D.C.,
Widener Collection

John Constable had long known General Francis Slater-Rebow and his wife and family; in 1812 he painted their seven-year-old daughter at their home in Wivenhoe Park in Essex, near Colchester on the southeastern coast of England. In 1816 the General ordered this view of his estate. During good weather Constable hurried there, and on August 30 he wrote: "The great difficulty has been to get in as much as they wanted. On my left is a grotto with some elms, at the head of a piece of water, in the center is the house over the beautiful wood; and very far to the right is a deer house, which was necessary to add; so that my view comprehended too large a space. But today I have got over the difficulty, and begin to like it myself." In this country panorama green grass and trees move into and out of sunlight. Reflections of grey and blue wind into the water, while boaters with a touch of red reinforce the bright color of the fertile scene. Grazing cows and two swans contribute to the Arcadian realism. Breathtaking in its scenic sweep and verdant amplitude, the painting presents a pleasing scene with everything in place; its summer freshness and clear country light contrasts with grey shifting masses of clouds rooted in the earth's horizon — all contriving to suggest a symbiotic relationship of man with nature. The painting finished and paid for, Constable, whose mind had been filled all along with thoughts of love and happiness, rushed off to marry Maria Bicknell.

· 10 ·

JOSEPH MALLORD
WILLIAM TURNER
(1775–1851)
*The Burning of the
Houses of Parliament*
(1834)

Oil on canvas, 36½″ x 48½″
Philadelphia Museum of Art
McFadden Collection

The Houses of Parliament, comprising the House of Lords and the House of Commons, began burning during the night of October 16, 1834. Hearing of the catastrophe, Turner hurried off to watch and sketch the scene in watercolors, later commemorating the event in three oil paintings. One of these, in the Cleveland Museum, shows the scene from a distance as Turner looked towards Westminister Abbey. In a second painting of the scene presented here, Turner takes us into the very jaw of the inferno itself, contrasting the solid masonry mass of the bridge, jammed with people, and the far end of the bridge with the adjacent land melting into a great heat of color. The near shore is crowded with spectators who are patched into the general movement of a mob; while on the river, boats heavy with passengers stream past or drift alongside the molten pot of liquid fire. The yellow golden and orange flames, contrasted with the shadows of blue smoke, evoke a Dantesque vision of destruction that dwarfs the onlookers. Both men and background are wound into a cosmic pattern of dissolution in the caloric colors churning the surface of the canvas to an intense visionary boiling point.

· 11 ·

CASPAR DAVID
FRIEDRICH
(1774–1840)
Wreck of the 'Hope'
(1821)

Oil on canvas, 38½″ x 51⅛″
Kunsthalle, Hamburg

Caspar David Friedrich shared the British Romantic preoccupation fusing all things into a supernatural unity, each thing reflecting that unity and every detail revealing its divine patrimony. Anthropomorphic characteristics shape gnarled trees and rugged rocks, mysterious horizons crush figures with the weight of an immovable eternity. Mist and snow, rain and atmosphere eat into the strange light of his scenes; and death, decay and accident threaten on every side the uneasy wayfarer whose spiritual path is difficult and tortuous, and whose faith must sustain him. Whatever Friedrich draws contains a symbolic presence, as in the *Wreck of the 'Hope'*, with the doomed ship pressed relentlessly into sheets of ice devouring it like great jaws of inevitability; the ship 'Hope' becomes man's hope, and its wreck the painter's silent reminder of human tragedy amid the harsh unpitying elements. (Friedrich's young brother had drowned in icy water.) Here the Romantic naturalism conveys overtones of the fantastic, of a yearning for some spiritual assurance constantly shattered by time's corrosion of man's tranquility. The spectator almost feels the juggernautic masses of blocks of ice, moving ominously along a slight diagonal, culminating in the crushing movement building into a threatening iceberg pyramid — as the knifethrusts of jagged ice drag along their helpless prey the 'Hope'.

· 12 ·

THEODORE GERICAULT
(1791–1824)
Raft of the 'Medusa'
(1819)

Oil on canvas, 193″ x 282″
Louvre, Paris

In 1815 the frigate 'Medusa' was wrecked off the coast of Africa. The ordeal of the survivors adrift on a raft in an endless sea inspired Géricault to paint a theme on the subject. He investigated the circumstances of the tragedy, interviewing the ship's doctors (one leaning against the mast, the other pointing to the rescue ship Argus almost imperceptible in the distance). The painting aroused official indignation; however, the artist's intention was not to criticize government inefficiency but to demonstrate the moral of human endurance in the face of adversity. Géricault studied symptoms of disease and the decomposition of corpses, even the movements of rafts in a turbulent sea. Models re-posed each dramatic gesture, with Delacroix simulating the dying man whose hand bends over a beam; the foreground figure with covering shroud later helped balance the composition. The strong diagonal upsweep of the figures — from the inanimate son supported by his father to the Negro signaling the distant Argus — moves against dramatic contrasts of light and intense dark, through which courses the discoloration of death and disease. The boldly sculptured masses of bodies weaving in and out accentuate the drama moving from the lifelessness of the foreground to the animation in an unsweeping diagonal. A wind violently sweeping through the scene and an opposing sea devouring the contours of the raft add to the feverish agitation of this gloomy episode set against the dark and boundless sea.

· 13 ·

EUGENE DELACROIX
(1798–1863)
The Massacre at Chios
(1824)
Oil on canvas, 166⅛" x 138⅝"
Louvre, Paris

The Massacre at Chios was labeled a "massacre of painting" by Delacroix's adversaries, who thought the young man had been too frank in his subject and too audacious in both composition and color. To his scene Delacroix added a background similar to that in Gros' *Battle of Eylau,* to indicate the setting of the action. Influenced by Gros, Delacroix here conceived of a military action, this time emphasizing not the conflicting armies but the fate of a civilian populace. He represents the Turkish massacre and enslavement of the Greeks on the Island of Chios, an episode in the stirring Greek war of Independence. In this moving treatment of a scene where the wounded and dying, the sick and crippled, even the aged occupy the foreground, Delacroix emphasizes the pathetic and lamentable, the terrible and gruesome. He recounts the frightening subject in colors evoking the calamity: greens and blues and reds appear in the wounds, and putrefaction of human bodies is evident, for example, in the dying mother with child. The composition is nervous and agitated, from the pathetic creatures on one side to the fiery horse and horseman with a captured Rubenesque nude woman on the other side. The work not only grapples with new painting techniques but appeals to contemporary sympathies and consciences, thus engaging the spectator's emotional participation in the drama on the canvas.

· 14 ·

EUGENE DELACROIX
(1798–1863)
The Death of Sardanapalus
(1827)
Oil on canvas, 155½" x 194⅞"
Louvre, Paris

In the catalogue for the 1827 exhibition Delacroix summarized the final episode in the life of Assyrian King Sardanapalus (836–817 B.C.), a theme inspired by Byron and other writers: "Reclining on a sumptuous bed high on an enormous funeral pyre, Sardanapalus gives the order to his eunuch and palace guards to stab his wives, his pages, even his horses and favorite dogs, so that nothing that afforded him pleasure might survive him." With the enemy at the palace gates, the doomed monarch calmly awaits annihilation through fire; at his feet the beautiful Greek Mrryha resigns herself to her death. Delacroix cascades the complex composition along an impetuous diagonal sweeping from the imperturbable figure of the monarch and fanning out to the figures moving in an undulating circle around the bed. Delacroix avoids emphasizing gruesome details by concentrating on the bodies enframed by the onrushing billowing smoke, in a palette filled with floral tones of white, yellow, orange and vermilion, red or pink intertwined with blues and greens in a traffic of dazzling hues. He keeps the surface in constant motion, curving in and out of the intricate construction of an object-burdened space. Contrasted with the expiring victims and the equerry restraining the fiery horse, Saradanapalus, aloof and calm, masters his Romantic fate by his unruffled reaction to the terror about him.

· 15 ·

JEAN AUGUSTE
DOMINIQUE INGRES
(1780–1867)
Odalisque with a Slave
(1842)

Oil on canvas, 28″ x 39⅜″
The Walters Art Gallery, Baltimore

Though adhering to the classical doctrine of well-balanced and isolated forms clearly related to each other, Ingres reveals a Romantic penchant in some of his subjects. In his *Odalisque with Slave*, a theme inspired by Lady Mary Montague's description of harem life in the Near East, the exotic and oriental mingle with the sensual and bizarre in a mood of languorous yearning. The Romantic bric-a-brac appears in profusion: attendant slave and eunuch, divans, carpets, hookahs all add to the lavish atmosphere of far-away. One version of this theme contains a limiting wall, opened here to reveal a fabulous garden in the distance. In this orderly disposition of space each object finds its proper place, and every element is subordinated to the motif of the human body — isolated, in Ingres fashion by outline, from the paraphernalia of the room and nearby attendant. A curious disjointed mechanism combines profile with a front-view of the body. Where Delacroix might turn a body energetically to indicate the merging and moving parts in the general movement of a painting, Ingres contains the diagram of the movement in clear areas, with a wave of sensuality coursing along the entire figure. Ingres deliberately evokes a Romantic vision, carefully calculating each element of the scene, so that his Romanticism is refined and filled with the tension of divergent movements locked in surface planes.

· 16 ·

THEODORE CHASSERIAU
(1819–1856)
The Two Sisters
(1843)

Oil on canvas, 70¾″ x 53″
Louvre, Paris

Chassériau, a Creole painter, began his career in the studio of Ingres, who saw in him the future "Napoleon of painting." He soon absorbed Ingres' linearism and clearly defined forms adhering, by a diminution of shadow, to the flat canvas surface. Later, influenced by Delacroix's stirring colors and exotic orientalism, he opted for Delacroix's verve, adding a strange oriental face with almost Arabic features on a svelte and limpid body. Through the years Chassériau used as subjects many of the members of his own family. In this double-portrait of his two sisters Adèle (1810–1869) and Alice (1822–1871) he reveals an Ingres-like disposition of figures in space, where human forms are accommodated by the rational area that must surround and define them. Chassériau has sympathetically observed his subjects, delineating forms in a subdued and cautious manner and suppressing the shadows where he can. But he gives his theme an immediate appeal, emphasizing the subtle planes of the face within sensuous shadows, intensifying expressions that are neither impersonalized nor reserved in an Ingres manner. Delacroix's rather than Ingres' color appears here, asserting itself forcefully as the framework on which the painter achieves his effect. Wherever he can, Chassériau appeals to our Romantic sympathy, by inviting the spectator's personal rapport with the intimate subject represented.

CHARLES FRANCOIS
DAUBIGNY
(1817–1878)
Evening
(1865)

Oil on canvas, 22¾″ x 36½″
he Metropolitan Museum of Art,
New York, Bequest of
Robert Graham Dunn, 1911

Intent on studying the interplay of land and water as affected by weather variations, Daubigny built a houseboat-studio to explore the interesting sites along the Oise River. In time his peculiar transport and his painterly notations became familiar to the Impressionists who admired his work — especially Claude Monet who collected examples.

In *Evening* humble and awkward houses reflect on their walls the deepening twilight, as the last sunlight slightly daubs the evening sky, silhouetting the simple masses of building and land and animals that now seem about to be absorbed into the oncoming darkness. The scene relies for its effect on its sparse vocabulary, within which Daubigny exploits all the nuances of light as it affects anything moving through it. The dying light is made intense by the contrast of gathering shadows; and while bravely illuminating the scene it adds a mystery of its own, hinting in its rapid transitions at the darkness soon to submerge it. The simple scene captures in its quiet sentiment the outdoor pageant of nature in all its multitudinous transformations; Daubigny studies these patiently. His Impressionist friends, whose work he publicly championed, relished his simple *plein-air*, or outdoor, method of direct and immediate communication of visual phenomena.

THEODORE ROUSSEAU
(1812–1867)
eaving the Fontainebleau Forest
(1850)

Oil on canvas, 55¾″ x 67¾″
Louvre, Paris

In 1833 Rousseau made his first long stay in the environs of Fontainebleau. His landscapes of that region, unsuccessful at exhibitions, were appreciated after the Revolution of 1848 — when he received a government commission for this painting. Exhibited in 1851, it proclaimed his attraction to this part of France where the great forest joins pastoral and farm lands and touches such villages as Barbizon. A collector of etchings by Rembrandt, van Ostade, Claude Lorrain, of Japanese prints and of paintings by Millet, Rousseau reveals diverse influences in this scene: in the Dutch solidity of trees conceived in a sensuous diurnal light, the Claude sunset moving in from the distance, Japanese chromatic colors of pink and blue to evoke the temporal setting, and Millet sentiment. He composes his picture by stressing the foreground with two wings of clustered trees enframing a single tree in the middle ground; a central pool catches reflections in its luminous depths and a volatile light absorbs the distance. Rousseau did not paint such scenes in the outdoors, but in his studio used sketches from which he evolved his composition, attempting to recreate a sensation experienced in his confrontation with nature. His painter friend Diaz prevented him from overworking his canvas, and thus destroying it; by this intervention Diaz helped preserve the spontaneity of the strong emotions Rousseau felt in rendering his theme.

· 19 ·

JEAN FRANCOIS MILLET
(1814–1875)
The Gleaners
(1857)

Oil on canvas, 32¾″ x 43⅜″
Louvre, Paris

Three gleaners move against a background of wheatfields, where groups of reapers and horse-drawn wagons bring sheaves to the ricks as a farmer on horseback looks on. Moving among the short stalks of yellow stubble, two women are busily gleaning. "I pray you, let me glean and gather after the reapers among the sheaves: so she came, and hath continued even from the morning until now . . ." (Ruth 2:7). The third woman, evidently older, momentarily rests.

Exhibited in 1857, the painting was praised by some and criticized by others who thought it appealed to the "wretched and destitute." Millet replied: "They may call me a painter of ugliness, a detractor of my race, but let no one think he can force me to beautify peasant types. I would rather say nothing than express myself feebly." Nevertheless Millet idealizes his figures and uses traditional poses in noble forms. The bold figures of the bending women move along a diagonal of the composition, while the semi-upright woman in profile contrasts with their movement and sets it into strong relief. Millet sculpts her figure with a broad shadow, though indicating the coarse and tired features of her face. The stooped posture and laborious gestures state the theme, while the rough garments and clubby hands supply a further social comment. Millet adds an expansive depth to the work by massing his shadows and dark areas in the foreground and diminishing the contrast of dark and light as the scene moves away from us.

· 20 ·

CAMILLE COROT
(1796–1875)
Cathedral of Chartres
(1830; retouched in 1872)

Oil on canvas, 24⅜″ x 19¾″
Louvre, Paris

After his return from Italy in 1825–28, where he had painted the great sites of Rome, Florence and Venice, Corot turned to the scenes of his native country. The Cathedral of Chartres is observed from the northwest: the west facade's twelfth- and near fifteenth-century towers; and the north porch near the pink facade of adjacent buildings. In the foreground Corot utilizes two *repoussoir* (or scaling-down) figures, a male and female, with small red color notes to set off the mounds of earth nearby and the great monument beyond. The figures are aligned with the slight diagonal view of the west portal of Chartres, with the intervening mound of earth reinforcing this diagonal disposition. The eye is led gently across the soft afternoon shadows on the Cathedral, as well as across the subsidiary buildings surrounding it. The absence of strong color flattens the painting into a sweeping movement, recession into depth is de-emphasized and all details are unified into a general light. Corot maintains an even tonality, keying the picture parts to each other and integrating details into harmonious planes; he does not stress the drama of towers against the sky but softens their forms against the grey background. Corot prefers subtle shadows and subdued color, simplifying the structure in a unified vision of epic serenity on a placid afternoon.

· 21 ·

HONORE DAUMIER
(1808–1860)
Crispin and Scapin
(ca. 1858–1860)

Oil on canvas, 23½″ x 32¼″
Louvre, Paris

After the Revolution of 1848 Daumier gave up political caricature for social themes dealing with the problems of daily life, executing, among other subjects, a number of drawings and lithographs of theater scenes. An extraordinary draftsman, he often drew from memory, recreating in his studio a heightened dramatic incident. Crispin (with white cuffs and short cloak) and Scapin were two intriguing valets in old Italian comedy who entered French comedy through Molière's *Fourberies de Scapin* of 1671 and flourished thereafter in other plays. Daumier concentrates on a revealing scene, a moment when the audience is absorbed in communal listening. Crispin whispers into Scapin's ear a message made tantalizing by the hidden mouth and the alert and absorbed listener's face. Daumier conceives his composition simply: the two figures, looming as clear silhouettes against the pastiche of a blue backdrop, are emphasized in dramatic linear contours; opposing dark and light masses buttress each other in a tense moment of communication. Daumier reinforces the outlines of their faces, stressing the action and reaction of each and contrasting profile with full-face; he broadly models the robust form in the cloak. In this painting, once the property of Charles Daubigny, stage props briefly indicate foliage in an economical evocative setting. The forceful and dramatic expression and the emotional intensity of the presentation help prepare the way for Van Gogh.

· 22 ·

EUGENE BOUDIN
(1824–1898)
*Normandy Women
Spreading Wash on the Beach*
(1865)

Oil on canvas, 18″ x 24″
Louvre, Paris

Boudin, who had taken lessons from Millet, once exhorted the young Claude Monet to "study, learn to see and paint, draw, do landscapes. The sea and sky, animals, people, trees are so beautiful, just as nature made them, with their character and genuineness, in the light and air, just as they are." In this painting Boudin, following his own advice, records whatever interests him. Though he composes along a perspective diminishing toward the center of the scene, he relates to it, in a most cursory way, the figures and objects, patterning the wash to one side but not on the other. His main figure moves away from the spectator toward a casually composed group of people. Boudin records the grey sky, the flat beach, the very unpretentiousness of the environs. He uses his color fluidly, giving us touches of the brushstrokes and vivacious dabs of paint. Boudin attempts to retain the first impression of his scene by "painting directly on the spot," approximating forms and structures with rapid brushstrokes, emphasizing the general overall texture that flickers through his scintillating brush, eliminating detail and recording atmosphere, weather, movements, the shifting masses of cloud and piled structure of sand; casual figures here and there accent the receding space in which land and sea are joined in grey monotony. This pre-Impressionist manner of painting, derived from the Barbizon masters and admired by Courbet, appealed to many young painters.

GUSTAVE COURBET
(1819–1877)
Funeral at Ornans
(1849)

Oil on canvas, 123½″ x 261″
Louvre, Paris

A *Funeral at Ornans*, begun late in 1849 and completed by May 1850, was exhibited in 1855 near the Paris World's Fair. The huge canvas, Courbet's ambitious manifesto of Realism, describes a scene in the lives of ordinary people. In critic Champfleury's words, "It represents the death of a citizen who is escorted to his last resting place by other citizens . . . It has pleased the painter to show us the domestic life of a small town."

At the very left is Courbet's deceased grandfather Oudot, the painter's most immediate reminder of death. Four pall bearers appear next: Crevot, Alphonse Promayet (a musician whom Courbet helped in difficult times) facing the spectator, Nodier and Bon; behind the brim of Bon's head appears the profile of writer Max Buchon (defender of Realism and Courbet's close friend). The parish priest officiates while two beadles, contrasting notes of red, pose behind the gravedigger. In the center stands the notary and deputy justice of peace Proudhon (near the painter's father Régis, a figure with high hat), the chief mourner for his cousin Pierre Joseph whose funeral this is, flanked by the fat mayor and two veterans of the Revolution of 1793 — in costumes of that period.

At the very right in the front, the woman leading the mayor's young daughter is Courbet's mother Susanne-Silvie; after the next woman come Courbet's three sisters (see Figure 16): sweet Zélie in profile, deranged Zoë with her face hidden by a handkerchief, and, with mouth covered, Juliette — the eccentric heir to her brother's paintings who donated this work to the Louvre Museum in 1881.

Courbet had difficulty in executing so large a canvas. He invited the townspeople to pose, one by one. Since he painted the work in a studio only a little larger than the canvas, he had "no room to step back" to study his problem of representing "fifty life-sized figures with background and landscape," as he explained. The compression of figures into a narrow space and their solemn arrangement across the canvas heighten the strange endlessness of the composition that seems to include the people of an entire village, all skirting the open grave that integrates them — along with the spectator — into the mournful theme of humanity.

The grey and black color scheme, relieved only by the ecclesiastic garments and small areas of red and white, and the crowded scene filled with bleak figures prompted many critics to speak harshly of the work: they described the scene as ugly and pedestrian and found fault with the composition, perspective, color and drawing — which they thought untraditional. In this scene, filled with the stubborn tenaciousness of humanity, existence is not idealized; for Courbet presents the homely subject matter he loves to paint. He emphasizes surfaces that are solid, with textural varieties in tactile surfaces, and the weight of physical bodies apparent. Later nineteenth-century painters turned their attention to such visual evidence around them, attempting to render their observations in a technique that would capture their optic sensations.

GUSTAVE COURBET
(1819–1877)
The Painter's Studio
(1855)
Oil on canvas, 141⅜″ x 234⅜″
Louvre, Paris

The Painter's Studio, a True Allegory Summarizing a Period of Seven Years in My Life as an Artist, the full title of this huge painting, was begun late in 1854 and included in Courbet's one-man show near the Paris World's Fair of 1855. Courbet wrote to his friend Champfleury: "The scene takes place in my studio in Paris; the painting is divided into two parts. I am in the center; on the right are the activists, that is, my working friends and the collectors of the art world. On the left, the other world of trivial lives: the common people, the destitute, the poor, the rich, the exploited, the exploiters: the people who thrive on death." Starting from the left are a Jew, a priest, a shabby old Republican of 1793, a hunter, a farmer, an athlete, a pierrot, a drygoods peddler, a worker's wife, a worker, a hired mourner, an Irish woman and child, an ordinary figure.

"Second part: Then come the canvas on my easel and myself painting, showing the Assyrian profile of my beard. Behind my chair stands a nude woman model." Then come "Promayet with his violin under his arm" and next to him are the art collector Bruyas, writers Cuénot, Buchon and Proudhon. "Then comes your turn [critic Champfleury] in the foreground; you are sitting on a stool with your legs crossed and your hat on your knees. Beside you, still near the front is an elegantly-dressed fashionable woman with her husband. Then to the extreme right, seated on a table . . . is Baudelaire reading a big book." At the back of the painting, "in the window embrasure are seen two lovers talking words of love."

To balance the composition, Courbet added the seated poacher and his dog, a shepherd boy admiring the painting of the Loue River in Courbet's native region the Franche-Comté, near Switzerland; on the floor another boy emulates the master. The beautifully realized nude (inspired by a photograph) symbolizes Nature watching the translation of reality into painting.

Above the crowded scene a background of gossamer painted panels rising behind the easel, contrasting with the actual view of nature through the window, lends surrealist overtones to the scene. Delacroix admiringly noted "the appearance of a *real sky* in the center of the painting." In this autobiographical canvas the artist attempts to synthesize the past decade to discover its meaning in his life. Elements of his experience are added up, portrait by portrait — each geared to the central theme: the artist himself, who is the clue to the enigmatic work.

The work is concerned with Courbet and his relation to the world and frankly establishes the importance of the artist's life as a theme. The Realist painter portrays a Romantic hero who imposes his art, along with his personality, on society — a nineteenth-century society increasingly unwilling to accept him on his own terms. Though rejected, the painter, vaunting his indifference, becomes adamant on the validity of his vision and the primacy of his art and existence. Such alienation of the artist from a hostile public isolates, and at the same time liberates, his talent to gestate as it will.